C000177102

LONDON

GERALD HOBERMAN

LONDON
GERALD HOBERMAN

*Photographs in celebration of London
at the dawn of a new millennium*

Text by John Andrew

UNA PRESS, INC.
in association with
THE GERALD & MARC HOBERMAN COLLECTION
CAPE TOWN • LONDON • NEW YORK

Photography and production control: Gerald & Marc Hoberman
Design: Gerald Hoberman, Marc Hoberman, Roelien Theron
Text: John Andrew
Editor: Roelien Theron *Layout:* Christian Jaggers
Cartography: Peter Slingsby

Mighty Marvelous Little Books are published for Una Press, Inc. by
The Gerald & Marc Hoberman Collection
PO Box 60044, Victoria Junction, 8005, Cape Town, South Africa
Telephone: 27-21-419 6657 Fax: 27-21-418 5987 e-mail: office@hobermancollection.com
www.hobermancollection.com

International marketing, corporate sales and picture library
Laurence R. Bard, Hoberman Collection (USA), Inc. / Una Press, Inc.
PO Box 880206, Boca Raton, FL 33488, USA
Mobile: (561) 542 1141 Fax: (561) 883 0482 e-mail: hobcolus@bellsouth.net

ISBN 1-919734-85-6

First published 2003, Reprinted 2004

Printed in Singapore

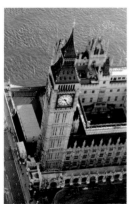

BIG BEN

Contents

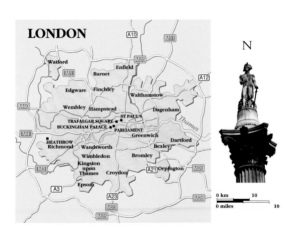

LONDON

A10 · M11 · M1 · M25 · A12 · A40 · M40 · M4 · M3 · A3 · A23 · M23 · M20

Watford
Enfield
Barnet
Edgware · Finchley
Walthamstow
Wembley · Hampstead
Dagenham
ST PAUL'S
TRAFALGAR SQUARE
BUCKINGHAM PALACE
PARLIAMENT
Thames
Greenwich
HEATHROW · Dartford
Richmond
Bexley
Wandsworth
Wimbledon
Bromley
Kingston
upon
Thames · Croydon · Orpington
Epsom

N

0 km · 10
0 miles · 10

INTRODUCTION

My maternal grandparents were Londoners who emigrated to South Africa just before the end of the 19th century. Sarah, my grandmother, was in her early twenties when she arrived in Cape Town. Although she lived happily there for more than seventy years, until the day she died she always referred to London as home!

London, a major capital at the crossroads of the world, is ever-vibrant with a constantly changing ebb and flow. It is the enviable quintessence of proud tradition and style and is at the cutting edge of modernity. Quaint customs from a past age and the world's best pageantry

dovetail into the hustle and bustle of everyday life, giving London its unique dimension.

It is not possible to include every facet of London in any one book. It is a special privilege, however, to be able to share my selection of London's attributes and my optimism with others through the medium of photography. This little book is a record for posterity of a great city and its people at the dawn of the new millennium

Gerald Hoberman

GERALD HOBERMAN
London

Right *A guardsman at St James's Palace.*

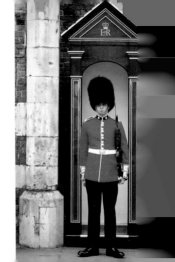

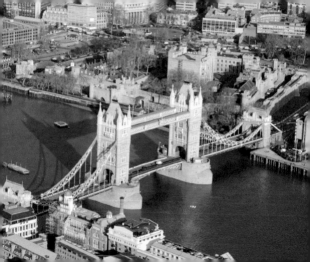

TOWER BRIDGE

Opened in 1894, this is London's best-known bridge. With the 787-feet (240m) roadway between the two towers raised, there is a clear width of about 197 feet (60m) and headroom of some 131 feet (40m) between which vessels may pass. It is a superb example of the Victorians' skill in combining engineering and architecture. The bridge was built in the neo-Gothic style to blend with the nearby Tower of London. The towers, which conceal the machinery for raising the bridge, consist of metal frameworks clad with stone.

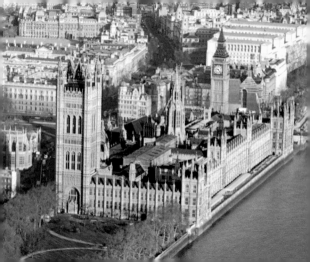

The Palace of Westminster

Steeped in history and traditions, the seat of the legislative body of the United Kingdom has an imposing 800-feet (244m) frontage on the banks of the Thames River.

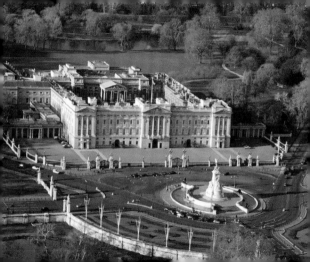

BUCKINGHAM PALACE

Few people realise that Buckingham Palace has grounds of some 45 acres (18.2ha). The lake used to be home to pink flamingos, a gift to the Queen from the Zoological Society of London. Unfortunately they were killed one freezing winter night during the mid-1990s by a fox that walked across the ice to their island quarters. The cunning fox correctly judged the thickness of the ice – in 1841 Prince Albert did not, and he skated to the bottom of the lake instead of on its surface.

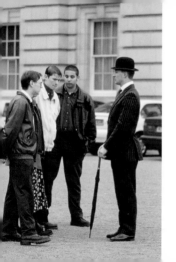

Students and a City gent *A Guards officer – looking quite the City gent from another era with his pinstriped suit, bowler hat and rolled umbrella – explains the Changing of the Guard to students visiting Buckingham Palace.*

Changing of the Guard *Marching to and from their barracks, the Queen's Guard is in three main groups: the regimental band with a Corps of Drums; the St James's Palace detachment, including the ensign who carries the Colour; and the Buckingham Palace detachment.*

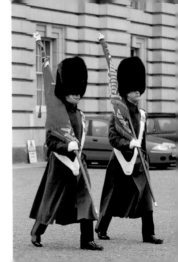

VISITING BUCKINGHAM PALACE

The Japanese ambassador, His Excellency Sadayuki Hayashi, rides past the Queen Victoria memorial at the head of the Mall en route to Buckingham Palace where he will be received at the Court of St James. He is accompanied in a state landau by his wife. Traditionally ambassadors are received by the Queen in the Audience Room of the palace. The official title of the royal court remains St James, even though ambassadors have not been received at St James's Palace since the 19th century.

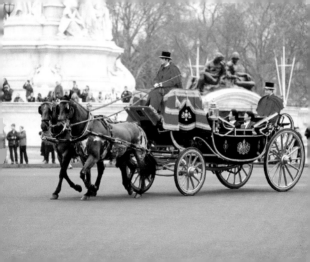

ROYAL MESSENGERS ON THEIR ROUNDS

Today, when commercial couriers speed through the streets of London on motorbikes and cycles, the royal messengers take a far more sedate form of transport – a Brougham. In the days of horse-drawn transport, it was considered the most useful carriage ever invented. The first was imported into England from Paris by Lord Brougham in 1837. Twice daily throughout the year, a Brougham leaves Buckingham Palace carrying messengers on their official rounds.

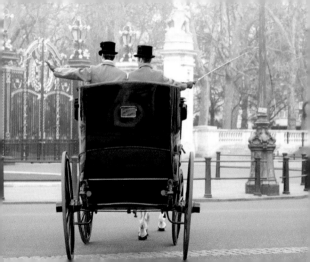

10 DOWNING STREET

The official residence of the prime minister is modest externally, but behind the façade there is a series of state rooms and offices. The building is in fact two houses, for in 1732 George II offered to give his principal minister, Sir Robert Walpole, 10 Downing Street and a house behind overlooking Horse Guards Parade. Walpole refused the personal gift, but asked the King to give the houses to the government as the official residence of the First Lord of the Treasury, a title modern prime ministers still hold.

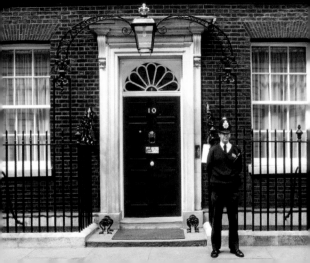

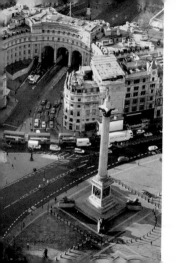

Nelson's Column and Admiralty Arch *Built in commemoration of Admiral Nelson's victory at the Battle of Trafalgar in 1805, Trafalgar Square's centrepiece is one of London's most famous landmarks – Nelson's Column, towering 183 feet (56m) above London.*

The Shakespeare's Head *A great deal of England's social history can be gleaned from the names of pubs. This splendid signboard is a reproduction of Martin Droeshout's engraving of William Shakespeare which appeared as the first folio of the Bard's plays published in 1623.*

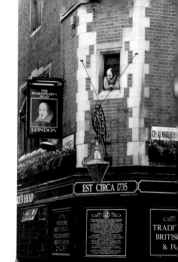

TRAFALGAR SQUARE

At Christmas an enormous fir tree adorned with white lights is erected in Trafalgar Square. It is a gift from the people of Norway as a 'thank you' for the assistance given by the British during World War Two. Traditionally the New Year was boisterously celebrated here, but in recent years the festivities have been discouraged because of the fear that overcrowding could result in tragedy.

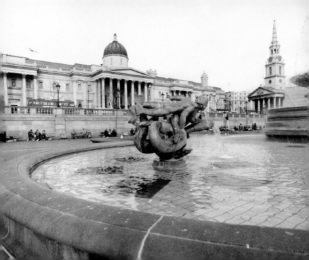

PICCADILLY CIRCUS AT NIGHT

Neon lighting was developed in the late 19th century. Its value for advertising purposes was quickly recognised and neon signs soon began to appear in the world's capitals. The shopkeepers with premises bordering Piccadilly Circus led the way in London. Initially relatively modest, the big splash came in 1923 when most of the façade of the London Pavilion became covered with neon signs. The reason why only the buildings on the northeast side are a blaze of lights at night is because the ground landlord for the rest is the Crown.

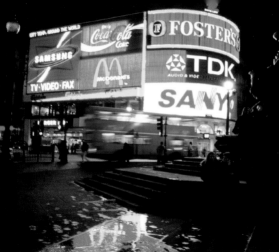

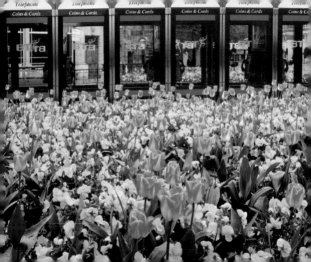

A City of Flowers

The City of London and the 32 boroughs that surround it form Greater London, which has an area of 609 square miles (1,579km^2). To relieve the feeling of a concrete jungle, many areas feature flower-beds, which add a splash of colour to the surroundings. The City of London has 173 planted areas and the City of Westminster 101, while the Royal Borough of Kensington and Chelsea has 85. Residents and businesses add to the extravaganza with windowboxes and other floral displays.

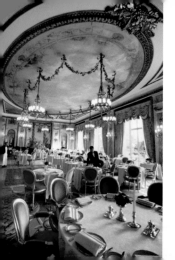

The Ritz restaurant

*The Ritz restaurant –
a perfect example of
Louis XVI boiserie –
is considered one of the
most beautiful dining
rooms in the world.
There one may experience
a repast in surroundings
which are a reminder of
the belle époque.*

Burlington Arcade Beadle *Lord Cavendish founded the corps of Burlington Arcade Beadles. Recruits enforced Regency laws which prohibited singing, humming, hurrying, making merry and staggering around with too many parcels — unless they were carried by a servant.*

A TRADITIONAL SHOESHINE IN BURLINGTON ARCADE

Wearing their smart uniforms, the shoeshiners from the Traditional Victorian Shoeshine Company are encountered daily at prime spots in central London and at major events like Royal Ascot. Their uniforms are inspired by the 'City Reds' Shoeblacks Brigade established by the Victorian philanthropist, Lord Shaftesbury. The brigade was formed to provide a shoeshine service at the Great Exhibition of 1851. It proved so popular that it continued for some years after the event.

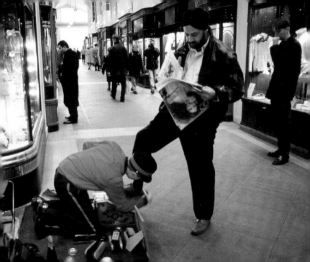

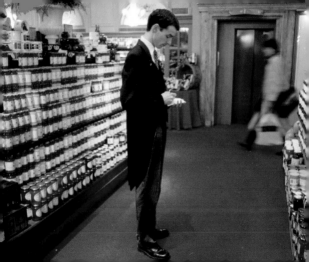

FORTNUM & MASON'S

While some eat to live, others live to eat. The clientele of Fortnum & Mason's certainly fall into the latter category, for here is a gourmet's paradise. When William Fortnum was employed as a footman in the royal household of Queen Anne, one of the perks of his employment was to be allowed to take the used candles which he then sold to the household's ladies. William persuaded Hugh Mason to join him in establishing a grocery business. The rest is history. The shop's ground-floor staff continue to carry out their duties in morning coats.

St James's Street *Berry Bros & Rudd Ltd (left) has been selling wine and spirits from the same premises in St James's since 1690 – the only wine merchant family in the world to have traded in the same building for so long. Established in the 1900s, John Lobb (right) creates handcrafted shoes.*

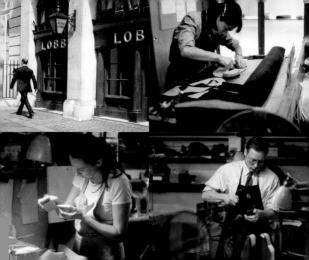

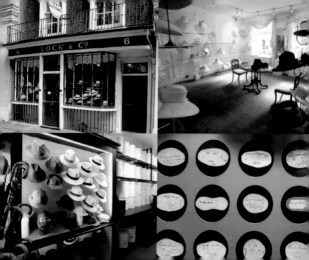

James Lock & Co., Hatters *Ray Parker, manager of James Lock & Co., the hatters established in St James's in 1676, holds a conformateur, a French invention which simplified the making of hard hats. The device, when applied to the client's head, exactly maps the head's contours.*

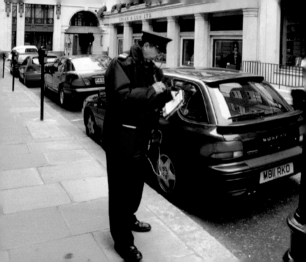

PARKING IN LONDON

Parking spaces are scarce in many parts of London: when available they are often expensive. This is particularly so of street parking. When it is permitted, it is generally upon the payment of a meter fee or by purchasing and displaying a voucher. Even then, parking is usually subject to a maximum of two hours. Around 5 million parking fines are issued in London each year. These can be for as much as £80. Should the vehicle be towed away, the release fee can be up to £125. There are usually 40,000 appeals against the fines each year.

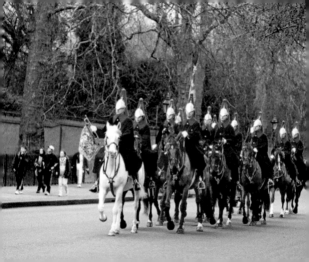

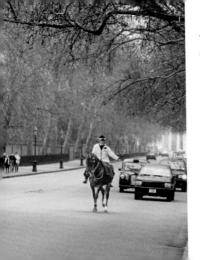

The Household Cavalry *The Queen's Life Guard is provided by the Household Cavalry regiment, stationed at Hyde Park Barracks. The regiment also provides the sovereign's escort for Her Majesty on all state occasions.*

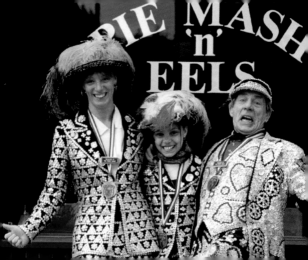

Pearly King, Queen and Princess of Peckham *The 'aristocracy' of the costermongers (street sellers), coster kings were originally elected in each borough to protect the rights of traders. Children inherit their parents' titles. In the 1880s Henry Croft, a road-sweeper and rat-catcher, decided to completely cover his clothes with pearl buttons, incorporating patterns and symbols. Today they are known as the Pearly Kings and Queens, and they undertake charity work and spread Cockney cheer.*

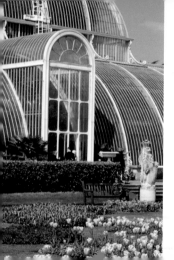

Royal Botanic Gardens, Kew *A visual delight for visitors, Kew also makes significant contributions to increasing our understanding of the plant kingdom.*

Right *In spring, bluebells flourish in this woodland in the Gardens.*

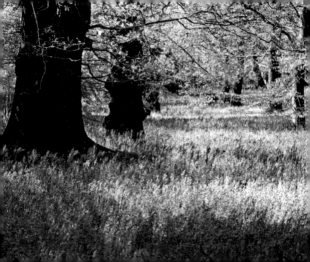

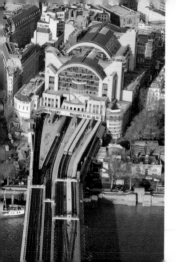

Embankment Place
*This nine-storey office
block built above
Charing Cross Station
(left) was designed by
Terry Farrell, a master of
spatial planning.*

Waterloo International
*It is now possible to
travel by Eurostar (right)
from London via the
Channel Tunnel to Paris.*

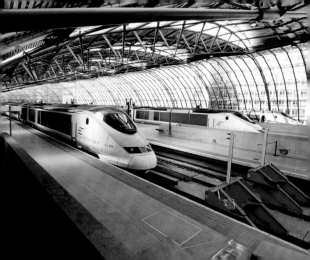

THE OLDEST UNDERGROUND RAILWAY

It surprises many Londoners and amazes all visitors that the London Underground runs to a timetable. However, technical disruptions aside, it in fact operates to a strict schedule. Today, comprising 243 miles (391km) of track, it stretches westwards to Amersham and eastwards to Upminster, respectively 26.71 miles (43km) and 18 miles (29km) from central London. Serving 275 stations, the system carries an average of 942 million passengers some 4,577,853,800 miles (7,367,000,000km) a year.

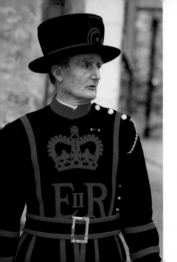

Yeoman Warder *In addition to performing their duties at the Tower of London, Yeoman Warders also attend the coronation of the sovereign, lyings in state, the Lord Mayor's Show and other state and charity functions.*

Right *The Tower of London.*

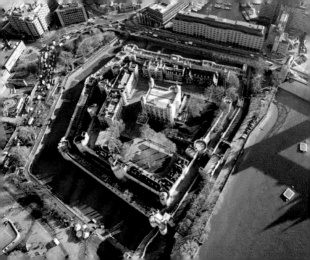

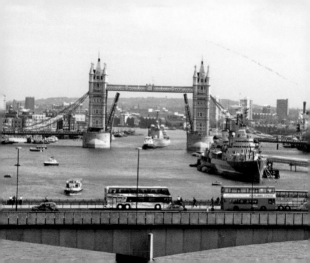

THE RAISING OF TOWER BRIDGE

A warship passes through Tower Bridge to berth alongside HMS *Belfast*, the cruiser built for the British Royal Navy in 1939 which is now permanently moored at Symon's Wharf. The bridge is raised about 500 times a year.

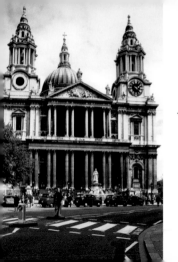

St Paul's Cathedral

The work of Sir Christopher Wren, St Paul's is an important feature of the London skyline. Its dome is the third largest in the world and the cross which surmounts it is some 366 feet (111m) above street level.

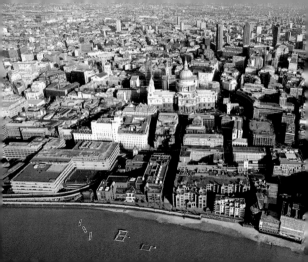

THE BRITISH MUSEUM

It is the most magnificent treasure house in the world, with a wealth and range of collections unequalled by any other national museum. The Rosetta Stone, the Elgin Marbles, Egyptian mummies, Botticelli and Michelangelo drawings, Assyrian reliefs, the Lewis Chessmen and the Sutton Hoo Treasure are all to be found here, together with some seven million other objects. Founded in 1753, today the museum attracts some six million visitors a year.

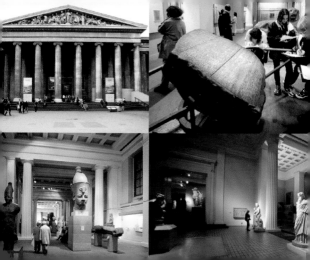

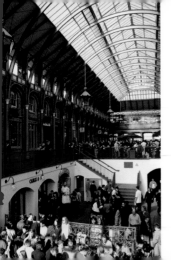

Covent Garden *Covent Garden grew from a few temporary stalls erected in 1656 in the garden of Bedford House, the home of the Earl of Bedford, to a major fruit, vegetable and flower market.*

Right *Street entertainers, Covent Garden.*

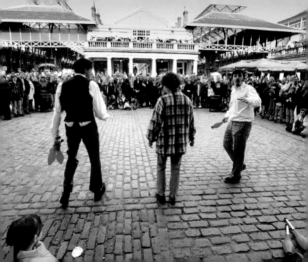

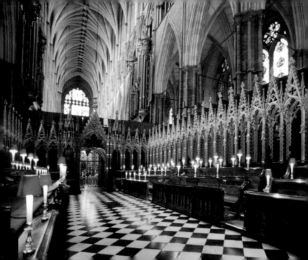

SERVICES AT WESTMINSTER ABBEY

There have been many joyous occasions in the abbey: coronations, baptisms and weddings, as well as services of thanksgiving. The serenity of this marvellous building is perhaps best experienced by attending one of the regular services. To hear the choristers accompanied on the very organ at which Henry Purcell played in the second half of the 17th century, is an experience which will not be easily forgotten.

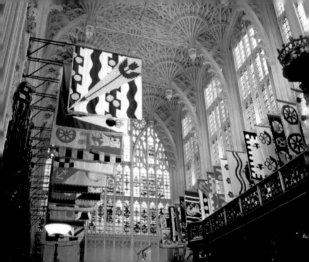

Henry VII's Chapel,
Westminster Abbey

Also known as the Lady Chapel, the glory of this Tudor masterpiece is its fine fan-vaulted ceiling. The American writer, Washington Irvine, described it as a place 'where stone is robbed of its weight and density, and suspended aloft as if by magic, and the fretted roof achieved with the wonderful minuteness and airy security of a cobweb'. John Leland, an historian at the time the chapel was constructed, stated simply that it was 'a wonder of the world'.

THE TOMBS OF WESTMINSTER ABBEY

There is far more to Westminster Abbey than carved stone, for it is a national shrine where many English monarchs and notables, such as Edward Talbot, 8th Earl of Shrewsbury (died 1618) and Jane, his wife (died 1626) (above), are buried. When Ben Jonson requested to be laid to rest here, he stated: 'Six foot long by two feet wide is too much for me; two feet by two feet will do for all I want.' He was buried upright. Undoubtedly the most poignant of all the tombs is the Unknown Warrior's, for this single grave is representative of thousands of dead.

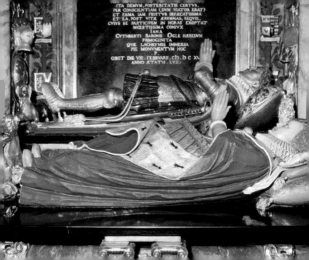

ITA DEMVM POSTERITATIS CERTVS,
PER CONSCIENTIAM (DVM VIATOR ERAT)
ET FAMA IAM PENITVS DEFAECATISSIMA
ET EA, POST VITÆ ÆRVMNAS, REQVIE,
CVIVS SE PARTICIPEM IN HORAS EXOPTAT
MŒSTISSIMA CONIVX
IANA
CVTHBERTI BARONIS OGLE HÆREDVM
PRIMOGENITA
QVÆ LACHRYMIS IMMERSA
PIE MONVMENTVM HOC
＿＿＿＿＿
OBIIT DIE VII. FEBRVARII. ᴄɪɔ. b c x v
ANNO ÆTATIS. LVII.

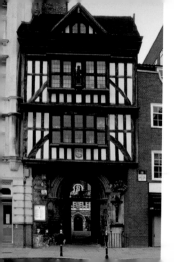

Priory House of St Bartholomew the Great
In 1916 a bomb fell nearby this gatehouse, displacing the tiles on its façade and revealing a 16th-century half-timbered building, London's oldest parish church.

Right *Kensington Palace.*

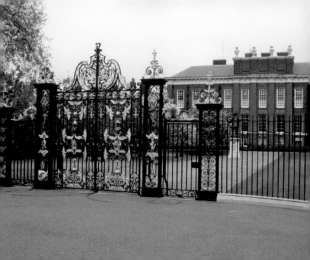

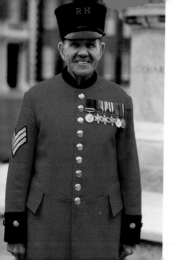

Chelsea Pensioner, the Royal Hospital – 1692
Inspired by the Hôtel des Invalides in Paris, in 1681 Sir Stephen Fox, the army's Paymaster General, suggested to Charles II that a similar home for veteran soldiers should be established in London.

The Dyers' Company Armorials *The dyers were first mentioned as a guild in 1188. The first Dyers' Hall was destroyed in the Great Fire of London in 1666.*

DA GLORIAM DEO

THE LONG ARM OF THE LAW

Author Henry Fielding sowed the seeds for the nation's police force. Appointed magistrate of Westminster in 1748, he established a group which eventually became known as the Bow Street Runners. Meanwhile, night foot patrols were established in 1782 and horse patrols on the main roads around London in 1805. Daytime crime prevention patrols started in 1822. The Metropolitan Police was established in 1829 with 1,000 officers. Today it employs 35,000 personnel.

ANTIQUES MARKET, PORTOBELLO ROAD

The world's largest antiques market takes place each Saturday in Portobello Road and the surrounding streets. It begins at 5.30am, although many dealers are there even earlier. Some travel hundreds of miles for the event. Numbering some 1,500, they trade from shops, fitted stands in arcades or from outside market stalls. It is not unusual for an item to change hands several times during the day. By 10am the area is crowded as both Londoners and tourists scour the market for bargains.

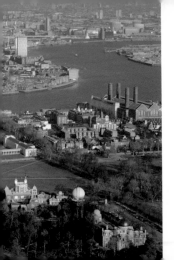

Left *The Royal Observatory, Greenwich.*

Right *The grounds at Hampton Court Palace are a kaleidoscope of styles, displaying gardening fashions popular through the centuries.*

Overleaf *London Eye.*